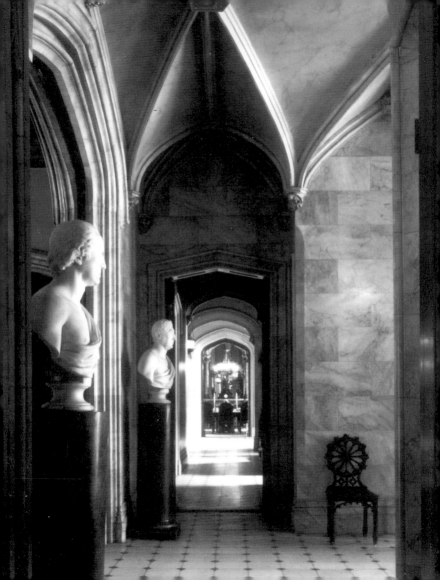

GOTHIC
REVIVAL

JAMES MASSEY & SHIRLEY MAXWELL

ABBEVILLE
STYLEBOOKS™

AN ARCHETYPE PRESS BOOK

ABBEVILLE PRESS · PUBLISHERS

NEW YORK · LONDON · PARIS

CONTENTS

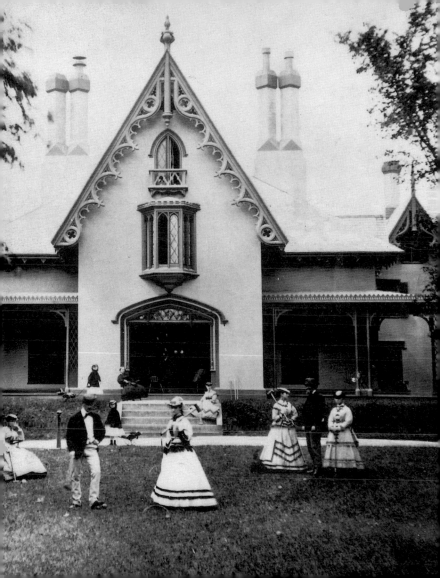

INTRODUCTION

And she glides through the greenwood at dawn of light
To meet Baron Henry, her own true knight.
—Sir Walter Scott, "The Lay of the Last Minstrel," 1805

When Victoria, the future queen of England, was born in 1819, the minds of many of her subjects-to-be were fixed with shivering delight on the romantic poems and novels of Sir Walter Scott. His tales were high-minded, picturesque, and full of robust action—just the ticket for an age overwhelmed by the inhuman clatter of a new industrialism. They helped spawn a vigorous "Battle of the Styles," a search for romantic designs that would express adventure, nationalism, modernity, and high moral purpose. The Gothic Revival and Italianate emerged as the most likely replacements for the classical, Renaissance-derived architectural styles that had prevailed for several centuries, besting the Egyptian, Moorish, Romanesque, and, in England, Tudor styles.

By the time Victoria donned her crown in 1838, Gothicism had become a heady mix of religion, literature, history, architecture, and landscape design based on the nineteenth century's view of life in the Middle Ages. For the next three decades, neo-Gothic ideals would battle—if never totally defeat—those of classicism. What was the point, critics demanded, of Greek temples in a Christian society? Of pagan post-and-beam construction when a Christian pointed arch was stronger? And how was any Christian comfort to be gleaned from the cold rationality of classical thought?

In the eighteenth century the Gothic style had been merely "goth-

ick." Architecturally, it was a giddy, rococo collection of pointed arches, trefoils, and castellated ornament tacked onto rich people's houses and garden structures. In the outpouring of late eighteenth- and early nineteenth-century romantic literature that helped popularize its ideals, early Gothicism was represented by a none-too-historical collection of knights and castles, fair maidens and far places, wild landscapes and noble deeds.

By about 1825 in England, France, and Germany (and later in America) an "ecclesiological movement" rejected churches that were too plain or "dishonestly" decorative; instead, it reached back to the Middle Ages—to the great, handbuilt Gothic cathedrals. There proponents found models for the wave of new church construction set off by the era's religious revival and even for "moral" housing types. Landscape artists, meanwhile, brought to verdant life the settings of Gothic romances in paintings and color lithographs.

As knowledge of the Middle Ages increased, Gothicism became more accurately applied. By the 1840s architects were able to build cathedrals and castles in true medieval fashion, and church leaders had found ways to use the construction principles of the Middle Ages for modern church architecture. Victoria and her popular consort, Albert—both tireless sponsors of British arts, manufactures, and social values—lent royal luster to the Gothic trend with their commissions for the furnishing of the royal residences at Windsor and Balmoral castles. Gothicism had become a serious matter indeed.

The Gothic Revival style held sway for churches well into the twentieth century. The academic world also rediscovered it, and large numbers of splendid university complexes continued to be inspired by images of the ancient buildings of Oxford and Cambridge.

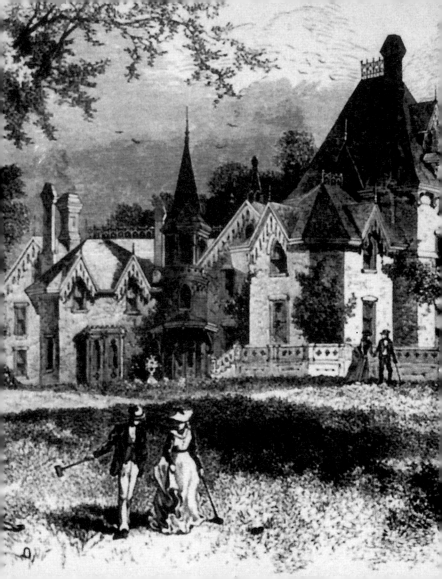

THE AGE OF ROMANCE

Midway through the industrial revolution, Gothicists found themselves leading a double life. In one was the world of the present: materialistic, urban, and rife with factories, railroads, coal mines, and steam power. And then there was the past—an idealized time somewhere between the Middle Ages and the early eighteenth century. Inspired by religious renewal and romantic literature, the Gothicists sought to recreate an atmosphere of piety, nobility, and adventure.

The John Earle Williams residence of Irvington, New York, was an Americanized combination of Elizabethan cottage, Gothic lodge, and Swiss chalet—highly romantic images all.

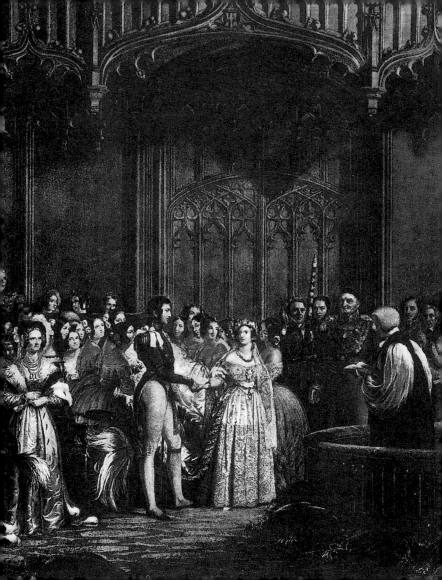

Viewed against the upheavals taking place in other parts of the Western world between 1840 and 1870, England in the Gothic Revival era might have seemed a tranquil place. While Great Britain set out to acquire colonies in Africa and Asia, European splinter states fought wars resulting in unified nations in Germany, Italy, and France. Japanese ports were opened to Western trade.

In the United States, the idea of Manifest Destiny marched across the continent, through the terms of nine presidents, the addition of ten states, the California Gold Rush, and the acquisition of vast territories in Alaska, New Mexico, and other western areas.

Technology brought an electrical telegraph system that outraced the Pony Express, and railroads made brand-new canals obsolete. Long-span suspension bridges leapt over formerly unspannable rivers. Steam-driven riverboats and ocean liners sped people and goods to far-flung destinations. Natural gas lighted city streets and homes. Photography came into its own.

As Gothicism's golden era began to wane, the Civil War helped end slavery in the United States, while in Britain horrific factory conditions led to the first child-labor laws.

In the Chapel Royal, St. James's Palace, Queen Victoria was married to Prince Albert of Saxe-Coburg-Gotha on February 10, 1840.

Our too sophisticated age may want the rich instincts of inventive genius, which in days of yore made our streets interesting, our houses loveable, and our churches sublime. It may want . . . the very social conditions which would render a return to the Medieval principles universally acceptable. But at least we have learnt . . . in what those principles consist.
—Charles L. Eastlake, *A History of the Gothic Revival,* 1872

| | 1824 | 1826 | 1828 | 1830 | 1832 | 1834 | 1836 | 1838 | 1840 | 1842 | 1844 | 1846 |

POLITICS & SOCIETY

■ British passenger trains begin service Morse telegraph demonstrated ■

McCormick reaper invented ■ Sewing machine invented ■

French Foreign Legion formed ■ Bigelow carpet loom made ■

B&O Railroad opens ■ Smithsonian Institution founded ■

First daguerreotype made ■ "The plow that broke ■
the plains" invented

Queen Victoria crowned ■ Mexican-American ■
War fought

Frederick Douglass escapes from slavery ■

Steamships cross Atlantic ■ U.S.–Canada suspension ■
bridge opened

First postage stamp mailed ■

Queen Victoria marries Prince Albert ■

LITERATURE & PERFORMING ARTS

■ Lord Byron dies at war *A Christmas Carol* (Dickens) ■

The Red and the Black ■ First minstrel show ■
(Stendhal)

The Hunchback of Notre Dame ■ "The Raven" (Poe) ■
(Hugo)

Tannhäuser (Wagner) ■

P. T. Barnum begins career ■ *Damnation of Faust* (Berlioz) ■

Jenny Lind debuts ■ *Jane Eyre* (C. Brontë) ■

The Fall of the House of Usher (Poe) ■ *Wuthering Heights* ■
(E. Brontë)

The Charterhouse of Parma ■ *Macbeth* (Verdi) ■
(Stendhal)

Punch begins publication ■

VISUAL ARTS & DESIGN

■ National Gallery, London, founded *Rain, Steam, and Speed* (Turner) ■

Mount Auburn Cemetery ■ Viollet-le-Duc restores Notre Dame ■
(Bigelow)

Trinity Church (Upjohn) ■

Rural Residences (Davis) ■

Laurel Hill Cemetery (Notman) ■

Cambridge Camden (Ecclesiological) Society ■

Houses of Parliament (Barry) begun ■

True Principles (Pugin) ■

Cottage Residences (Downing) ■

Lyndhurst (Davis) ■

| | 1824 | 1826 | 1828 | 1830 | 1832 | 1834 | 1836 | 1838 | 1840 | 1842 | 1844 | 1846 |

1848	1850	1852	1854	1856	1858	1860	1862	1864	1866	1868	1870	1872

POLITICS & SOCIETY

- Revolutions overtake Europe
- *Communist Manifesto* published
- California Gold Rush begins
- Amelia Bloomer changes fashion
- California becomes a state
- German confederation formed
- French Second Empire initiated
- Perry negotiates treaty with Japan
- Nightingale nurses at Crimean War
- Garibaldi unites Italy
- Transoceanic cable completed
- Otis elevator developed
- Bessemer steel process invented
- Oil discovered at Titusville, Pa.
- U.S. Civil War begins
- Civil War ends
- Abraham Lincoln assassinated
- Canadian Dominion formed
- Austro-Hungarian Empire founded
- Suez Canal opened
- Trans-continental U.S. railroad completed

LITERATURE & PERFORMING ARTS

- *Lohengrin* (Wagner)
- Jenny Lind tours U.S.
- *The House of Seven Gables* (Hawthorne)
- *Uncle Tom's Cabin* (Stowe)
- The Ring Cycle (Wagner)
- *Walden* (Thoreau)
- *Leaves of Grass* (Whitman)
- Sarah Bernhardt debuts
- Stephen Foster dies
- *Crime and Punishment* (Dostoevsky)
- *Peer Gynt* (Ibsen)
- *Blue Danube* (Strauss)
- *Tales from the Vienna Woods* (Strauss)
- *The Conduct of Life* (Emerson)

VISUAL ARTS & DESIGN

- Pre-Raphaelite Brotherhood founded
- Wheeling, W.Va., Suspension Bridge (Ellet)
- Old Louisiana State Capitol (Dakin)
- *The Seven Lamps of Architecture* (Ruskin)
- *Kindred Spirits* (Durand, Hudson River School)
- *The Architecture of Country Houses* (Downing)
- Crystal Palace (Paxton)
- Balmoral Castle rebuilt
- Central Park (Olmsted and Vaux)
- *Discourses on Architecture* (Viollet-le-Duc)
- All Saints, Margaret Street (Butterfield)
- Boston Public Garden (Meacham)
- Salon des Refusés, Paris
- Dominion Parliament Buildings (Thomas Fuller)
- Llewellyn Park, N.J. (Davis)
- *The Dream of Dante* (Rossetti)

1848	1850	1852	1854	1856	1858	1860	1862	1864	1866	1868	1870	1872

Andrew Jackson Downing, landscape architect and author, was a tireless promoter of picturesque rural architecture in America before his early death in a steamboat explosion.

The grounds of Blithewood in Duchess County, New York, typified Downing's idealized vision of rural life. The estate on the Hudson River was drawn by architect A. J. Davis and published in Downing's *Treatise on Landscape Gardening* in 1841.

Throughout the Gothic Revival period, most people lived pretty much as their ancestors had, on farms and in country villages. Yet the lure of the city, with its factories, offices, and shops, grew stronger. Small, rural water-powered mills, where families labored in a relatively benign environment, gave way to large, sooty factory towns where lives were blighted by dismal conditions.

Industrialization built a large and sturdy middle class, however, and supplied the goods that middle-class life required—including attractive homes in healthful surroundings. Outside cities rose Downingesque rural "cottages" in the Gothic mode and miles of green and beckoning suburbs. Horse-drawn rail cars bore the man of the house to work and back. His wife stayed home, of course, where she was often overwhelmed by the rigors of caring for her new house in the face of servant shortages, as more and more young women chose factory work over service in private homes. New devices filled some gaps. Iron cook stoves supplanted the open hearth, sewing machines replaced much hand sewing, and—for a fortunate few—gas lights and indoor plumbing banished oil lamps, chamber pots, and privies.

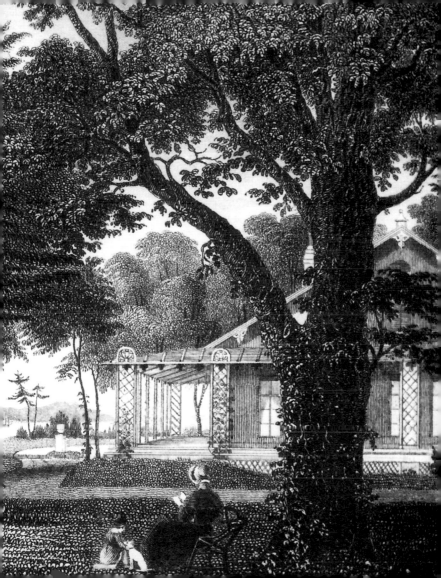

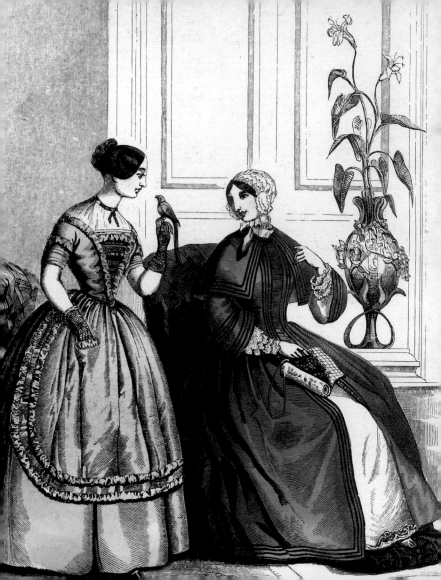

At the beginning of the Gothic period, stylish ladies wore voluminous conical sleeves and bell-shaped skirts covered by full-length pelisses. Atop their corkscrew curls perched large, lacy bonnets. By the 1840s the pelisse was gone, and skirts were noticeably rounder, requiring yards of stiff petticoats and crinolines beneath. Basque-waisted bodices with short sleeves and discreetly swooping necklines revealed milk-white arms and shoulders, while back-sloping bonnets exposed smooth, winglike hairstyles. Gentlemen wore frock coats and narrow, pegged trousers and always tipped their stovepipe hats when encountering a lady.

In the 1850s and 1860s women—rejoicing at the introduction of lightweight metal hoops that kept their ever-wider flounced skirts in shape—jettisoned some of their petticoats for dainty pantaloons. Prince Albert's extensive use of plaid fabrics at Balmoral Castle set off a corresponding stir in women's fashions. After Albert's death in 1861, Victoria's long public mourning made black fashionable and helped create a thriving market for mourning apparel. Gothic jewelry was not common, but somber Gothic designs in wrought iron enjoyed a brief popularity.

A fashion plate in the August 1850 *Godey's Lady's Book* showed this apron worn as part of a "morning costume." It could be silk, muslin, or gingham.

Balmoral petticoat: Red-and-black striped underskirt intended to show beneath a walking skirt

Balmoral boots: Walking boots laced up the front, popularized by Queen Victoria

Bloomer costume: Suffragist Amelia Bloomer's skirt-over-trousers suggestion for emancipated women's dress

Knickerbockers: Below-the-knee breeches worn by boys and sportsmen in the 1860s

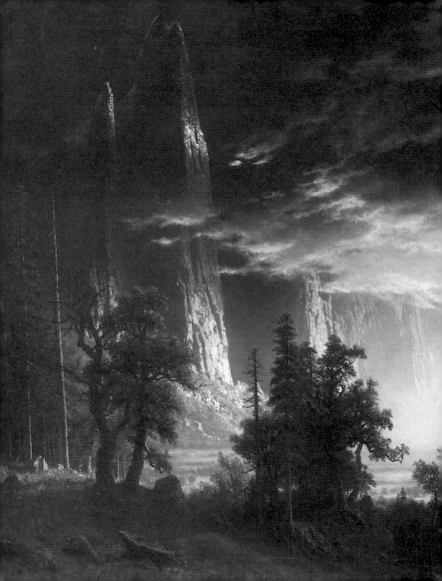

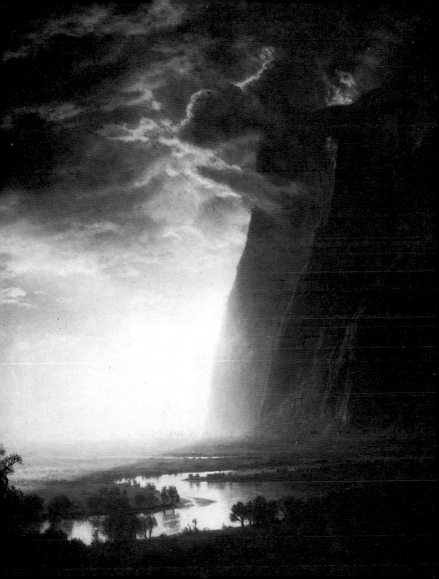

Gothic Tales

Frankenstein (1818,
Mary W. Shelley)

*The Hunchback of
Notre Dame* (1834,
Victor Hugo)

"The Raven"(1845)
and *The Fall of the
House of Usher* (1839,
Edgar Allan Poe)

The Scarlet Letter (1850,
Nathaniel Hawthorne)

Moby Dick (1851,
Herman Melville)

Chromolithography
brought fine-art repro-
ductions to middle-class
parlors—landscapes
such as Bierstadt's 1868
*Sunset in the Yosemite
Valley* (pages 18–19)
were favorites. Decora-
tive covers and litho-
graphs enhanced books
of all types, including
A.W.N. Pugin's 1841
masterwork (opposite).

Wrestling with dark themes of mortality and morality, the Gothic romance novel practically created the Gothic era. Although Jane Austen poked literary fun at the genre as early as 1818 in *Northanger Abbey,* romantic novels enthralled several generations of readers with tales of fictional heroes like Sir Walter Scott's *Rob Roy.*

Gothic enthusiasts also doted on dramatic, naturalistic landscape painting, a field dominated in America by artists of the Hudson River School, such as Thomas Cole, Albert Bierstadt, Asher B. Durand, and Frederic Church. In England, Dante Gabriel Rossetti and the Pre-Raphaelite Brotherhood produced lyrical renditions of medieval scenes. Sculpture with funereal themes had particularly Gothic overtones well suited to the sentimental bias of the period.

Music also turned toward the dramatic. Wagner and Verdi churned out popular operas with romantic plots, and the heroic strains of Schumann, Brahms, and Berlioz thrilled listeners. A craze for choral music and oratorios led to the cultivation of a rich new voice type, the contralto, and the heavy tones of the piano replaced the delicate tinkling of the harpsichord in parlors and concert halls.

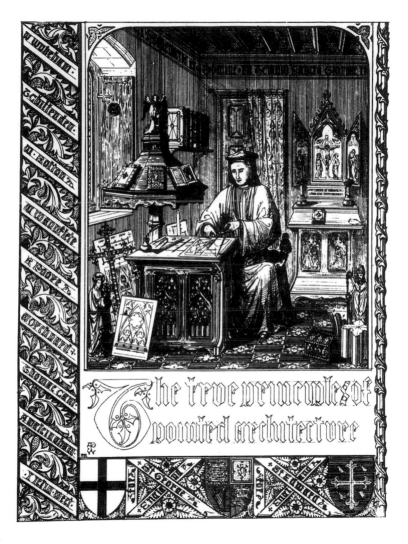

The true principles of pointed architecture

THE POINTED STYLE

Heralded as "the only proper style" for English church building, Gothic Revival was also promoted in the nineteenth century—a time of surging nationalism—as the most appropriate national style for *all* English buildings. Americans liked it, too, but as just one of several romantic styles to be molded at will to Victorian American tastes.

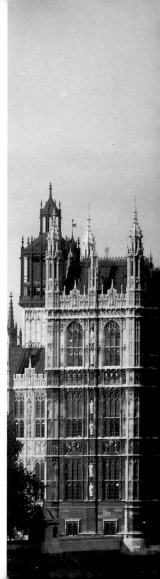

The Houses of Parliament (1840–70, Sir Charles Barry) in London encouraged municipalities on both sides of the Atlantic to adopt the Gothic Revival style. Called "amiable and august," the landmark has outstanding Tudor-Gothic interiors by A.W.N. Pugin.

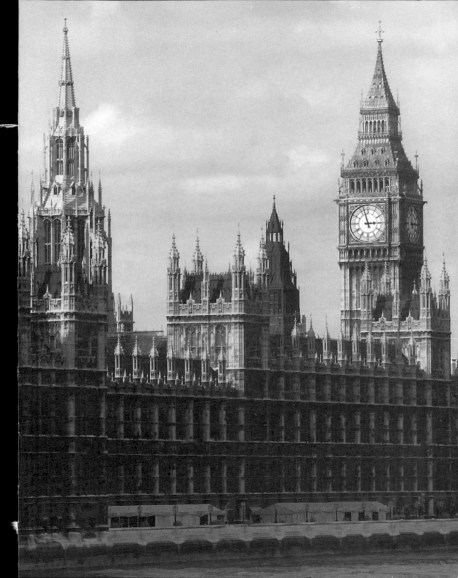

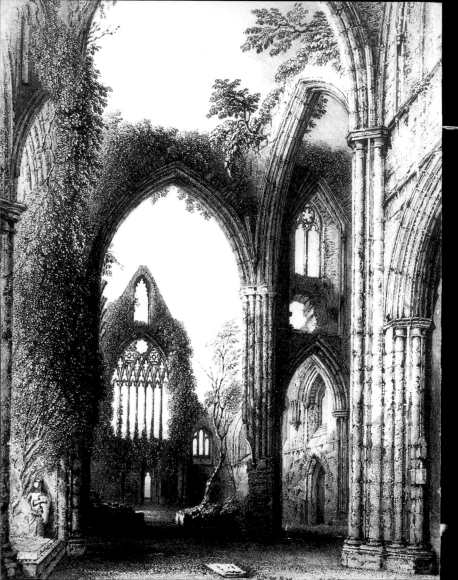

A PICTURESQUE OBSESSION

No architectural feature is more gloriously Gothic than a pointed arch. At windows, doorways, dormers, and gables, the thin, aspiring arch urges the eye heavenward, reminding the observer that this style is firmly rooted in the religious architecture of the Middle Ages. Gothic began to supplant Romanesque in the mid-twelfth century but generally yielded to Renaissance themes in the 1500s. It had never quite died out when it enjoyed a resurgence in the late 1700s.

The resulting Gothic Revival was, like its Gothic prototypes, a vital, spiky, ceaselessly active mode—in striking counterpoint to the calm symmetry of classicism. Pointed arches were joined with high, steep roofs, ribbed vaulting, and flying buttresses, all intended to allow impressive, soaring height without sacrificing space and light within.

Gothic Revival buildings were often based on cathedrals, but the towered medieval castle was an alternative. The most Gothic of the buildings were asymmetrical and picturesque, with towers, wings, turrets, bays, and oriels. Serious study of the Gothic past merged with the romantic art and literature of the times to feed an obsession with the picturesque forms so amply supplied by the pointed style.

In the eighteenth and nineteenth centuries the public was drawn to ruins of medieval Gothic churches such as Tintern Abbey in England, a picturesque reminder of a past romantic age.

Why Gothic Was Popular

1. It represented "loftier" moral precepts of an earlier day, in contrast to contemporary secular and industrial society.
2. It suited the revival of Christian church ritual from the Middle Ages.
3. It fed public fascination with the romance of the medieval past.
4. It furthered nationalism with a single, national architectural style.

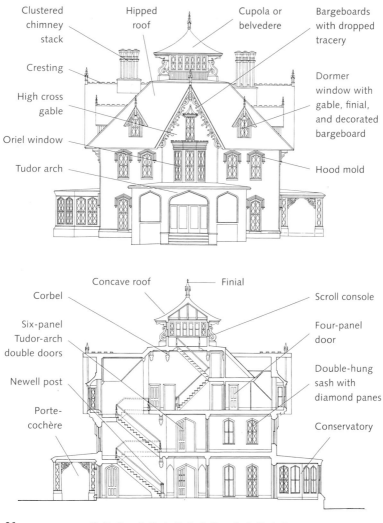

Clustered chimney stack

Hipped roof

Cupola or belvedere

Bargeboards with dropped tracery

Cresting

High cross gable

Oriel window

Tudor arch

Dormer window with gable, finial, and decorated bargeboard

Hood mold

Concave roof

Finial

Corbel

Scroll console

Six-panel Tudor-arch double doors

Four-panel door

Newell post

Double-hung sash with diamond panes

Porte-cochère

Conservatory

Arches: Pointed or lancet, curving to a point; also, Tudor and ogee.

Roofs: Steep, pitched gables rising high to a sharp ridge; sometimes, cross gables (gables in three or four directions) in the ridges.

Towers: Tall, square, or octagonal towers above the roofline, occasionally in more than one stage, with decorative spires, pinnacles, and gargoyles.

Boulderburg (1852), in Rockland County, New York, is a well-dressed—if not over-dressed—Gothic villa, complete with a prominent cupola.

Plans: Either formal and balanced or asymmetrical and picturesque.

Materials: Stone, especially for churches; brick; or wood siding, either flush or vertical board-and-batten (as in Carpenter Gothic structures).

Colors: Muted, natural earth hues in browns, ochers, umbers, and grays; dark red or dark green accents.

Doors: Pointed-arch panels set in Gothic-arch openings; occasional sidelights or transoms with diamond panes

Windows: Casement or double-hung; bay or oriel windows; Gothic tracery, stained glass, or diamond panes.

Porches: Large verandas and porches across the front and perhaps the sides of a house.

Ornament: Medieval shapes and moldings copied in stone or wood, including pinnacles with crockets and finials reaching upward; pendants hanging downward with bosses, barge-boards, or vergeboards on eaves filled with fancy carved shapes such as trefoils or quatrefoils; and rooflines with medieval battlements or ridge cresting.

Columns: Round or octagonal, with floral or leaflike capitals, grouped or clustered in a massive shaft; in churches, rising to form the ribs of a vaulted ceiling.

MEDIEVAL MODELS

The most influential American architect of rural Gothic residences, A. J. Davis, contributed many designs to Downing's books.

Strawberry Hill in Twickenham, England, was remodeled by Horace Walpole with a light and joyous flurry of Gothic details. Walpole wrote *The Castle of Otranto* (1764), an early Gothic novel.

Sir Horace Walpole's Strawberry Hill, remodeled 1747–63, was among the first English buildings to suggest the secular appeal of the Gothic style. Sir Walter Scott's own picturesque, antiques-filled Scottish castle, Abbottsford (1812), quickly became a popular Victorian destination.

By the mid-1820s English church reformers were urging a return to the more elaborate churches of the Middle Ages and the more formal church ritual of the era. To A.W.N. Pugin, a noted restorer of medieval churches and the persuasive voice of English perpendicular Gothicism, the style represented the only true Christian architecture—certainly the only one suited to church building. John Ruskin, art critic and moral adviser for the period, preferred the polychromatic Venetian Gothic. In France, the great advocate of Gothicism was an agnostic restorer of castles and cathedrals, Eugène Viollet-le-Duc.

The leading American proponents of the Gothic Revival style, author and landscape architect Andrew Jackson Downing and architect A. J. Davis, drew only loosely on historical antecedents in the design of their popular rural villas and cottages for the up-and-coming middle class.

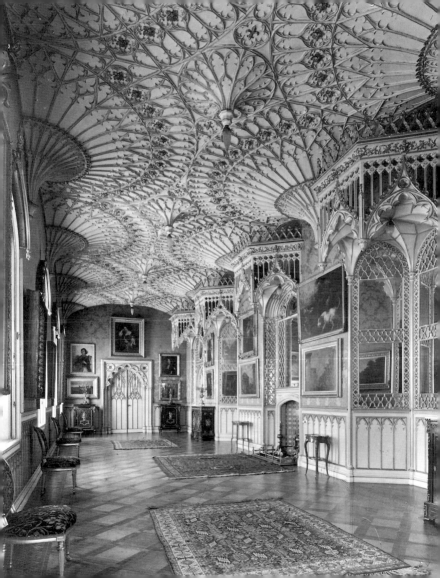

ARCHITECTS

Sir Charles Barry (1795–1860)
Houses of Parliament, London
(1840–70)

William Burges (1827–81)
Trinity College, Hartford, Conn.
(1881)

Decimus Burton (1800–81)
Palm Stove, Kew (1848)

**William Butterfield
(1814–1900)**
All Saints, Margaret Street,
London (1859)

R. C. Carpenter (1812–55)
St. Paul's, Brighton (1849)

**Ralph Adams Cram
(1863–1942)**
U.S. Military Academy,
West Point, N.Y. (1903–14);
Princeton University Graduate
College, Princeton, N.J.
(1911–29);
St. George's School Chapel,
Newport, R.I. (1928)

A. J. Davis (1803–92)
Lyndhurst, Tarrytown, N.Y.
(1842, 1865);
Virginia Military Institute,
Lexington, Va. (1848–61)

Thomas Fuller (1822–98)
Dominion Parliament Buildings,
Ottawa, Canada (1867)

Frank Furness (1839–1912)
Pennsylvania Academy of the
Fine Arts, Philadelphia (1876);
Provident Life and Trust,
Philadelphia (1879)

**Maximilian Godefroy
(1765–1840)**
St. Thomas, Bardstown, Ky.
(1816)

G. M. Kemp (1795–1844)
Sir Walter Scott Monument,
Edinburgh (1846)

**Benjamin H. Latrobe
(1764–1820)**
Sedgeley, Philadelphia (1799);
Bank of Philadelphia (1808)

**Robert Carey Long, Jr.
(1810–49)**
St. Alphonsus, Baltimore
(1842);
Franklin Street Presbyterian
Church, Baltimore (1846)

Elijah E. Meyers (1832–1909)
City Hall, Richmond, Va. (1894)

John Nash (1752–1837)
Luscombe, Devon (1804);
Blaise Hamlet, near Bristol
(1811)

John Notman (1810–65)
Laurel Hill Cemetery,
Philadelphia (1839);
St. Thomas, Glassboro, N.J.
(1840);
St. Mark's, Philadelphia (1852);
Hollywood Cemetery,
Richmond, Va. (1860)

Sir Joseph Paxton (1803–65)
Crystal Palace, London (1851)

**Augustus Welby Northmore
Pugin (1812–52)**
St. Oswald's, Liverpool (1842);
St. Giles, Cheadle (1846)

James Renwick (1818–95)
Grace Church, New York
(1846);
Smithsonian Institution,
Washington, D.C. (1855);
St. Patrick's Cathedral,
New York (1879)

**Sir George Gilbert Scott
(1811–78)**
Albert Memorial, London
(1872);
St. Pancras Station and Hotel,
London (1874)

**Richard Norman Shaw
(1831–1912)**
Holy Trinity, Bingley, England
(1868)

G. E. Street (1824–81)
St. James-in-the-Less, London
(1861);
Royal Courts of Justice, London
(1882)

Ithiel Town (1784–1844)
Trinity Church, New Haven,
Conn. (1816)

Richard Upjohn (1802–78)
Kingscote, Newport (1841);
Trinity Church, New York
(1846);
St. Mary's, Burlington, N.J.
(1846)

Henry Vaughan (1845–1917)
St. Paul's School Chapel,
Concord, N.H. (1894)

**Heinrich von Ferstel
(1828–83)**
Votivkirche, Vienna (1879)

Frank Wills (1822–56)
Christ Church Cathedral,
Frederickton, Canada (1853)

**Frederick Withers
(1828–1901)**
Gallaudet College,
Washington, D.C. (1867–85);
Jefferson Market Library,
New York (1878)
(with Calvert Vaux)

LANDSCAPE DESIGNERS

**Andrew Jackson Downing
(1815–52)**
*A Treatise on ... Landscape
Gardening* (1841)

**Frederick Law Olmsted
(1822–1903)**
Central Park, New York
(1858–76);
Prospect Park, Brooklyn, N.Y.
(1867);
Riverside, Ill. (1870) (all with
Calvert Vaux)

Calvert Vaux (1824–95)
Central Park, New York
(1858–76);
Jefferson Market Library,
New York (1878)

RESTORERS

**Sir George Gilbert Scott
(1811–78)**
Ely Cathedral, Ely (1847 on);
Westminster Abbey, London
(1849 on);
Salisbury Cathedral, Salisbury
(1859 on)

**Eugène Viollet-le-Duc
(1814–79)**
Notre Dame, Paris (1845–64);
Amiens Cathedral, Amiens
(1850–75);
La Cité, Carcassonne
(1852–72)

WRITERS & CRITICS

Jane Austen (1775–1817)
Northanger Abbey (1818)

Catharine Beecher (1800–78)
American Woman's Home
(1869)

A. J. Davis (1803–92)
Rural Residences (1837)

**Andrew Jackson Downing
(1815–52)**
Cottage Residences (1842);
*The Architecture of Country
Houses* (1850);
Rural Essays (1853)

Owen Jones (1806–89)
Grammar of Ornament (1856)

**Augustus Welby Northmore
Pugin (1812–52)**
*The True Principles of Pointed
or Christian Architecture*
(1841)

John Ruskin (1819–1900)
*The Seven Lamps of
Architecture* (1849);
The Stones of Venice (1851)

Sir Walter Scott (1771–1832)
"The Lay of the Last Minstrel"
(1805);
Ivanhoe (1820);
Kenilworth (1821)

Calvert Vaux (1824–95)
Villas and Cottages (1857)

**Eugène Viollet-le-Duc
(1814–79)**
Dictionnaire raisonné
(1854–68),
Discourses on Architecture
(1858–72)

Horace Walpole (1717–97)
The Castle of Otranto (1764)

ENGINEERS

I. K. Brunel (1806–59)
Royal Albert Bridge, Saltash
(1859);
Clifton Suspension Bridge,
Bristol (1864)

James B. Eads (1820–87)
St. Louis Bridge, St. Louis
(1874)

Charles Ellet, Jr. (1810–62)
Niagara Suspension Bridge,
Niagara Falls, N.Y. (1849);
Wheeling Suspension Bridge,
Wheeling, W. Va. (1849)

John A. Roebling (1806–69)
Niagara Suspension Bridge
replacement (1855);
Wheeling Suspension Bridge
replacement (1861);
Cincinnati Suspension Bridge,
Cincinnati, Ohio (1867);
Brooklyn Bridge, Brooklyn, N.Y.
(1883)

Thomas Telford (1757–1834)
Conway Suspension Bridge,
Wales (1824);
Tewkesbury Mythe Bridge,
England (1826);
Menai Suspension Bridge,
Wales (1826)

PUBLIC LEADERS

**Queen Victoria (1819–1901)
Prince Albert (1819–61)**
Great (Crystal Palace)
Exhibition, London (1851);
Balmoral Castle, Scotland
(1855)

[B]uild a porch or point a window, if you can do nothing else; and remember that it is the glory of Gothic architecture that it can do anything.

—John Ruskin, 1853 lecture

All Souls Church (1860, Sir George Gilbert Scott), Halifax, Nova Scotia, is among the grandest, most full-blown expressions of Gothic Revival church architecture in North America. For true Gothicists, medieval ways of building died hard even in the nineteenth century's industrial age.

Although construction technologies developed in the nineteenth century made flying buttresses and pointed arches structurally redundant, it never occurred to nineteenth-century church designers to abandon their Gothic ways. If it had, iron beams and portland cement might have replaced stone church construction altogether. Fortunately for the cause of progress, others responded quickly to the era's innovations.

Improvements in transportation—including unintentionally Gothic-looking cast-iron suspension bridges, railways, canals, steamships, and road systems—made accessible an enormous range of exotic building stones and other materials. Steam-powered sawmills provided the seemingly flimsy 2-by-4s that allowed sturdy buildings to be raised quickly in the new balloon-framing system. In the United States, westward migration brought new building types—and often larger buildings—as newly settled towns built colleges and universities, post offices, courthouses, jails, factories, hotels, and theaters. In England, too, urbanization and industrialization created a demand for larger buildings and creative ways of dealing with society's grittier challenges.

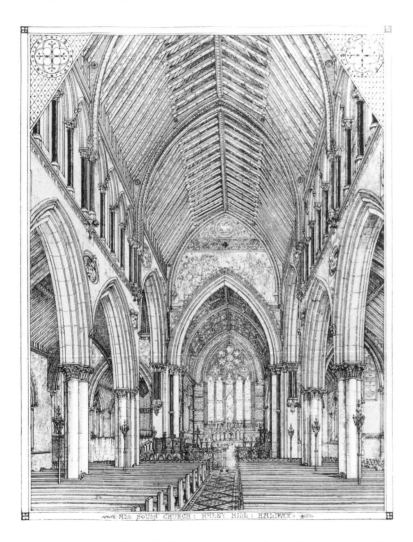

ALL SOULS' CHURCH : HALEY HILL : HALIFAX ·

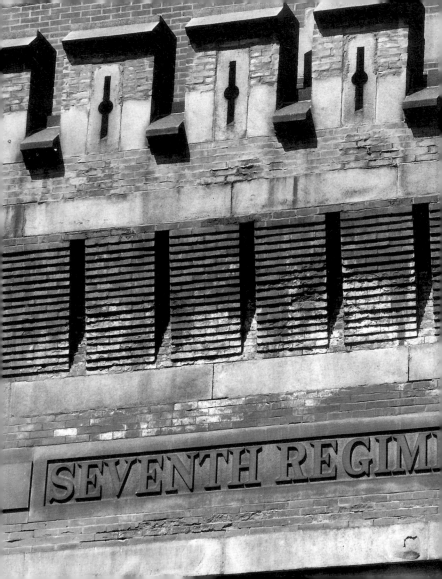

OUTSIDE

Any structure with the slightest claim to Gothic origins must have its share of pointed arches—or a tower or turret or two. While "organic" and "functional" were favorite descriptive terms for these complex, asymmetrical structures, they were, above all, intensely and unabashedly romantic. The romantic effect is striking even in buildings that, on close inspection, are found to be symmetrical classical boxes disguised by Gothic furbelows.

The battlements of medieval castles proved good models for nineteenth-century Gothic Revival armories, including this one built for New York's Seventh Regiment (1880, Charles W. Clinton).

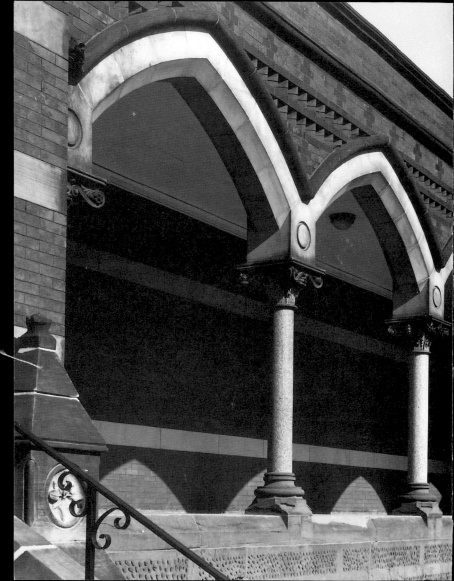

Gothic Revival buildings were most often built of stone or wood, less often of brick. The most imposing of them—churches, mansions, university and government buildings— wore dressed stone, frequently brownstone, sometimes green serpentine, or, from the late 1800s, dressed limestone. In the United States small houses and churches were likely to have board-and-batten wood siding.

Experts agreed that subdued, natural hues best suited Gothic structures—definitely *not* white. The Episcopal bishop of Vermont in 1836 ordered everything "light and gaudy," except stained glass, left out of new churches, advocating warm but sober tones: light brown or yellowish drab for stone, English oak stain or a light olive brown for woodwork. For country houses Andrew Jackson Downing urged soft colors from nature—a quiet fawn or warm gray, for instance. The poet Wordsworth condemned cold, slaty hues and "flaring" yellow in favor of "something between a cream and a dust color."

In the 1870s and 1880s came a more flamboyant, polychromatic style: Venetian or High Victorian Gothic, advocated by John Ruskin. Others thought such license too much a departure from the only proper style.

There is always, perhaps, something not quite agreeable in objects of a dazzling whiteness.
—Andrew Jackson Downing, *The Architecture of Country Houses,* 1850

Contrasting colors of brick and stone, a Ruskinian or High Victorian Gothic treatment, enliven a pointed arcade at Gallaudet College in Washington, D.C., and recall a medieval monastery cloister. The campus was designed between 1867 and 1885 by Frederick C. Withers, who had worked briefly with Downing.

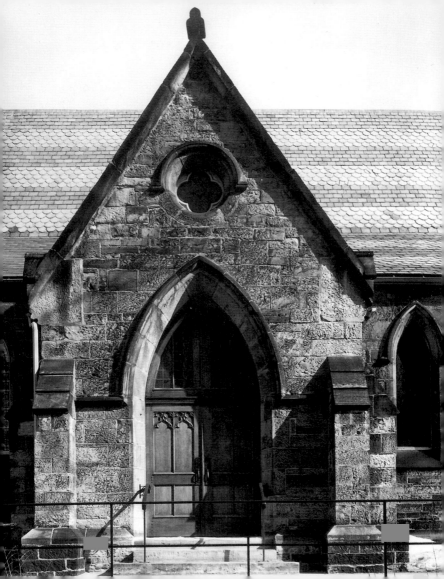

DOORS AND WINDOWS

A truly satisfying Gothic entrance probably intimidated visitors more than it welcomed them. The best examples led through massive, paired, dark oak doors carved with arched panels and fastened with heavy iron locks and hinges. Simpler portals might consist of plain but heavy vertical board doors.

Flanking sidelights and transoms with pointed-arch tracery often helped avert a sense of oppressive sobriety—for, despite their penchant for solemnity, Gothicists were as greedy as their fellow Victorians for sunlight and fresh air. Consequently, Gothic Revival houses tend to have a great many windows. Singly, or in pairs or multiples, romantic casements with dozens of tiny, diamond-shaped panes evoked medieval precedents. More modern double-hung windows were common as well, sometimes with hints of Gothic tracery, sometimes plain. Glazed, clover-shaped openings—trefoils, quatrefoils, and even cinquefoils—adorned buildings of all types. In churches, brightly glazed rose windows dazzled worshipers. Stained glass, almost a requirement in Gothic Revival religious structures, was frequently found in residences as well. Dormer windows often harbored the ubiquitous arch.

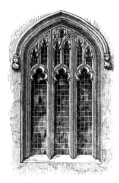

This tripartite Gothic window in the perpendicular style, published in 1848, dates from the last and most decorative Gothic phase.

Richard Upjohn's Christ Church (1855), Binghamton, New York, exemplifies Gothic ornament and design: a steep gable, buttresses, and a large pointed-arch entrance. Above the door is a simple quatrefoil window.

Every tower built during the pure style of pointed architecture either was, or was intended to be, surmounted by a spire. A flat roof is both contrary to the spirit of the style and it is also practically bad.
—A.W.N. Pugin,
The True Principles, 1841

Streets of miniature Gothic cottages made the Wesleyan campground at Oak Bluffs, Massachusetts, the most famous of all the many religious camp meeting grounds of the nineteenth century. Here church members could combine religious fervor with relaxation.

A steep, showy, gabled roof—or, whenever it could be arranged, several roofs intersecting at various angles—clad in slates set in intricate, multicolored patterns or wooden shingles in a variety of shapes was virtually de rigueur for pointed Gothic Revival buildings. Multiple roofs not only satisfied the romantic spirit of the age; they also, Gothicists claimed, were helpful in accommodating the varied functions of an efficient, asymmetrical nineteenth-century house plan.

An alternative and equally picturesque roof treatment could be found in medieval-like castles, in which a nearly flat roof was tucked behind machicolated battlements. Ornate chimneys, often with clustered stacks resembling Gothic colonettes, climbed high above the rooflines.

Pointed arches gave Gothic support to small, one-story entrance porches and full-length verandas that, although less than historically correct, were too dear to the Victorian heart to be overlooked. In the United States particularly, the elaborate sawn-wood ornament that gave rise to the term Carpenter Gothic was almost sure to find its place along the eaves of a porch and on the bargeboards of its steep gables.

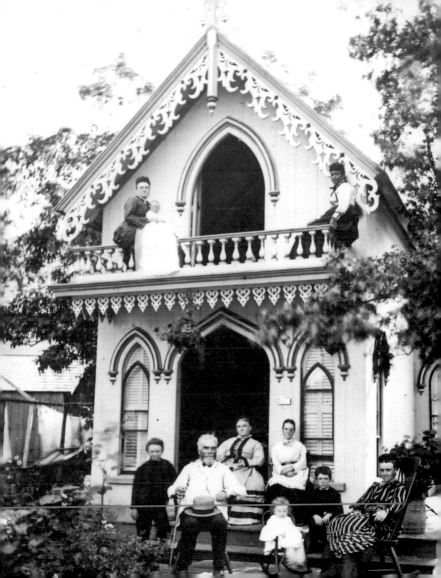

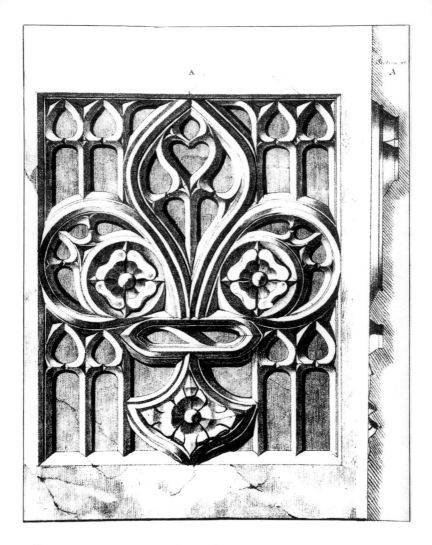

A

While purists of Gothic Revival insisted that ornament and structural function be clearly related, builders were likely to take a more insouciant approach. Always, of course, there was the arch—sometimes structural, sometimes purely decorative.

Intricate cornices and moldings enlivened facades, while clusters of short, slender columns and pilasters bore capitals carved with realistic or surrealistic leaf and floral forms and animal shapes. Spearlike pinnacles with leafy crockets of cast or wrought iron soared above the rooflines, while pendant ornament hung crisply from the eaves.

In timber-rich America small houses of wood and brick blossomed with lacy, machine-cut, wooden "gingerbread" in intricate Gothic patterns at bargeboards, gables, eaves, and porches—all in light-hearted imitation of the stone carving found on masonry buildings of the fifteenth century.

Pointed architecture does not conceal her construction, but beautifies it.
—A.W.N. Pugin,
The True Principles,
1841

Pugin's 1831 book, *Gothic Ornaments,* copied ancient English and French designs and became a primer for architects and stone carvers. Typical illustrations are an oak panel (opposite) and a stone stringcourse ornament (below).

A great deal of the charm of architectural style, in all cases, will arise from the happy union between the locality or site, and the style chosen. . . .

—Andrew Jackson Downing, *Cottage Residences,* 1842

Downing's books offered not only designs for houses but also site and landscape plans— to ensure that "happy union." This plan for a cottage in the pointed style placed the kitchen garden (f) and the orchard (g) on the choicest soil. The property sloped down to the bank of "one of our boldest rivers."

In their gardens as in their buildings, Gothicists opted for a naturalistic and picturesque approach. The Gothic Revival garden was not an orderly outdoor setting of tightly clipped parterres and classical statuary but a kindly wilderness in which the goal was to celebrate nature rather than conquer it.

Writers such as John Claudius Loudon, in England, and Andrew Jackson Downing and Frank J. Scott, in America, preached to an eager audience in new and fashionable residential suburbs that combined the best of nineteenth-century city and rural life. Gardeners were advised to build "cottages" and villas that would sit as naturally on their sites as trees and grass. Conversely, they were encouraged to plant pointed trees—particularly evergreens—that echoed the steep gables of Gothic houses and churches.

Meandering paths wound through clusters of trees and shrubs to rustic summer cottages and covered benches made of saplings. Lawnmowers did not come into wide use until 1870, but grassy lawns were popular; open front yards sharing space and views were considered a neighborly duty. Cast-iron fences and garden furniture were stylish if not quite comfortable accessories.

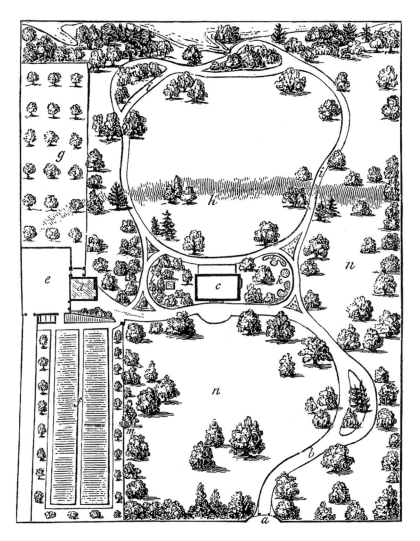

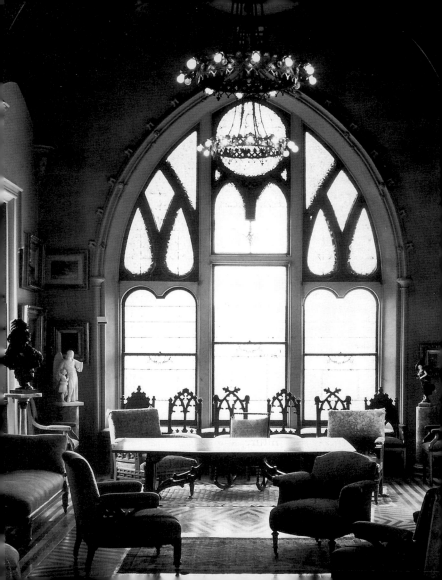

I N S I D E

Floor plans in houses opened up even as room uses became more specialized. Modern conveniences undreamed of in medieval castles — central heating, bathrooms and kitchens with running water, and natural-gas light — began to show up in middle-class houses, at least in the United States. Gothic decoration proved as delightful indoors as out, appearing on machine-made wallpaper and fabrics, mass-produced furniture, and factory-made lighting fixtures.

In the library at Lyndhurst (1842, 1865, A. J. Davis) in Tarrytown, New York, all features work to convey the quintessential Gothic message.

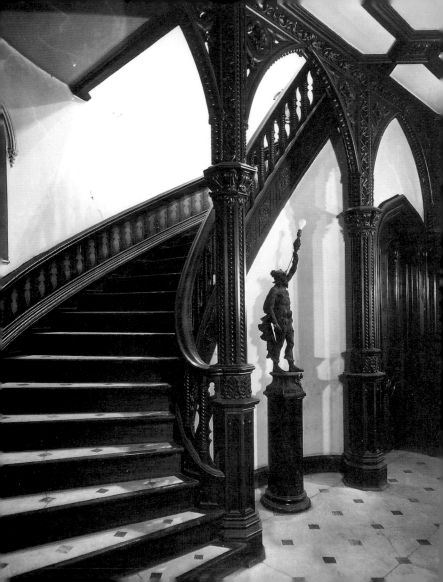

Although Pugin, Downing, and others insisted on the moral necessity of honest building materials, legerdemain played a powerful role in the average Gothic Revival building. Overhead, colorfully painted imitation vaulting in molded plaster over wood was functionally useless but aesthetically acceptable. The grandest houses might boast of linenfold-paneled walls of fine mahogany, walnut, or darkened oak. More often, however, a simple wainscot of pine, painted or stained, would do well enough. Wood or plaster moldings in complex shapes bore evocative names: chevrons, billets, cable moldings, ball-flowers, bird's-head, beak-head, cat's-head, and twining-stem.

Staircases were no longer so likely to be the dominant interior design feature and were often less prominently located and less elaborately executed than in earlier days. Pointed and Tudor arches, trefoils, and quatrefoils were everywhere—on doors, walls, and staircases, at fireplaces, and as tracery in windows. Bunched columns and colonettes supported mantels and bookshelves. Fireplaces might be of marble—or wood, cast-iron, or slate somewhat "dishonestly" decorated to look like marble.

Ornate bosses decorate the vaulted ceiling of the Church of the Holy Cross (1852, Edward C. Jones), Statesburg, South Carolina.

The Singer house (1869), Pittsburgh, has fine Gothic Revival interiors, including this magnificent curving staircase set behind a pointed-arch arcade.

PAINT AND WALLPAPER

Florid, highly shaded wallpapers were popular despite the disapproval of critics. This Gothic design at the Ebenezer Maxwell mansion (1859, Joseph C. Hoxie), Philadelphia, undoubtedly would have found disfavor with Pugin.

There should be one dominant hue in the room, to which all others introduced are subordinate. This will admit of many variations of shade, passing from green to blue, or venetian red to brown, without requiring absolute uniformity of tint throughout.
—Charles L. Eastlake, *Hints on Household Taste*, 1878

Paint colors moved from whites and clear tints to the earthy tones favored by Gothic colorists, with bold accents of blues and reds. Touches of gold leaf further highlighted the effect. Complicated color schemes for walls required different colors or patterns in the dado, field, and frieze, topped by a multicolored cornice.

Machine-printed wallpaper, readily obtainable by the American middle class in an endless array of colors and patterns, supplemented fine block prints from Europe. Scenic papers continued to be used also, but they were likely to depict medieval rather than classical scenes as in previous years. Abstract, arched, floral, and foliate designs were popular as well, but arbiters of Gothic taste reminded buyers to avoid overly realistic designs and stick to flat, unshaded, artistic patterns. Ashlar patterns imitating stone walls were popular for halls, in either paper or paint. As with paint schemes, papered walls were treated in not one but several patterns, from dado to frieze. Deeply colored silk and damask sometimes were used to rich effect on walls. Grained wood finishes often concealed plain pine on doors and woodwork, while paint simulated marble on baseboards.

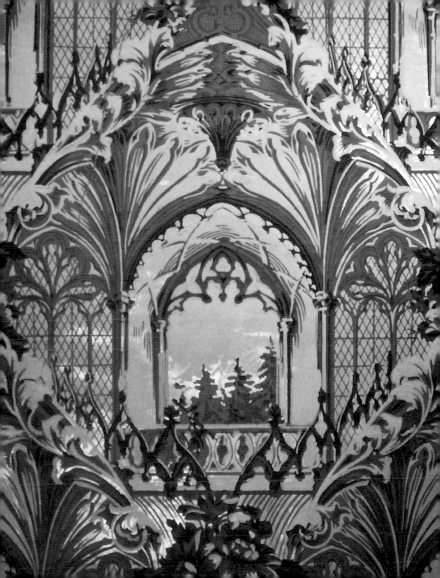

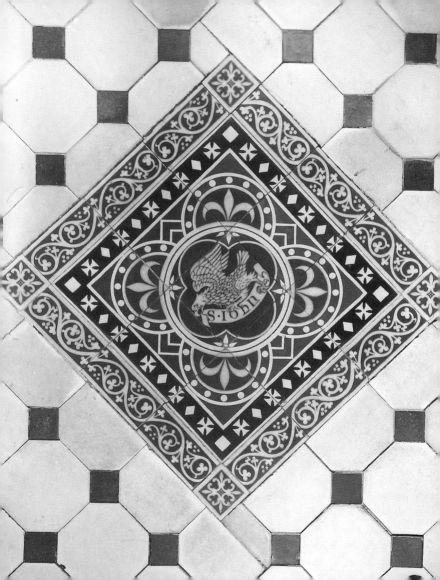

FLOORS

In grand Gothic Revival entrance halls, no flooring was quite so impressive as marble tiles, usually gray and white or black and white, laid in diamonds or squares of contrasting colors. Hardwood floors might be found in any of the major rooms of a fine house, but pine was a more common choice: it was generally expected that wall-to-wall carpeting would cover it. During the course of the nineteenth century, floor boards became progressively narrower, as the wide boards of the previous century fell from public favor.

These were also the years that ushered in the revived use of ceramic floor tiles, often in imitation of those found in old abbeys and cathedrals. The medieval English form of tile rapidly gained currency with Gothic Revivalists and was widely used in halls and around fireplaces. The basic floor tile was an octagonal, unglazed encaustic tile in simple medieval patterns or plain colors, laid in contrasting designs, sometimes with small tesserae at the intersections. More colorful patterned and glazed tiles with fleur-de-lis or trefoil designs, for example, soon followed, and these were later used for wall surfaces as well.

Encaustic floor tiles reviving medieval English traditions were popular at midcentury and later for both churches and houses. This example comes from the Church of the Holy Cross (1852, Edward C. Jones), Statesburg, South Carolina.

Popular Flooring

Gray and white marble tiles for halls

Encaustic tiles for major rooms and fireplaces

Pine floors, stained and polished or covered with wall-to-wall carpets

Finished wood floors, often alternating dark and light boards or contrasting painted boards

Soil cement or brick floors in basements

One of the most important changes in nineteenth-century houses was the development of the bathroom. Well-furnished ones had a tin or copper tub, and the toilet might be a modern valve water closet.

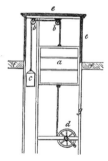

The best-equipped houses were provided with efficient dumbwaiters to speed the passage of food and dishes from kitchen to pantry or dining room. Downing provided this example in 1842.

A major comfort source arrived on the mid-nineteenth-century building scene with the introduction of central heating systems. They fed warm air throughout a building through ducts running from a coal-fired furnace in the basement to ornamental brass registers in floors and walls. Although fireplaces with coal grates remained in wide use, middle- and upper-class houses often benefited from the more modern heating system, particularly in the United States. By the end of the Gothic Revival period, steam and hot-water radiators had come into use.

Water was routinely pumped inside for kitchens and bathrooms, either from city supplies or private wells, increasing access to the modern comfort of a bathroom equipped with sink and toilet. Natural gas was piped in from municipal mains or private plants for light, not heat, and cooking was generally done on coal ranges.

The importance of adequate ventilation for health reasons also took hold of the public consciousness. Especially in the southern United States, elaborate systems were devised to bring cool air up from under porches, through the house, and then out through a central cupola.

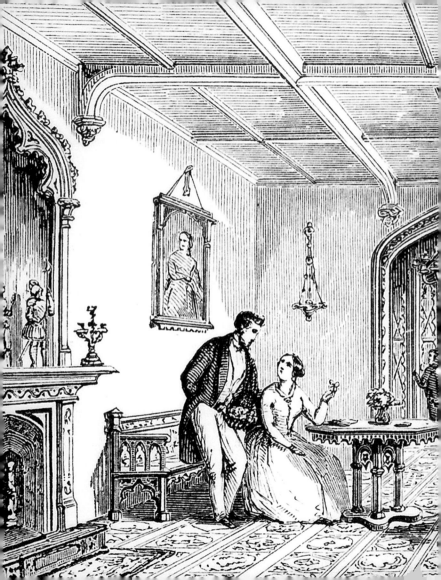

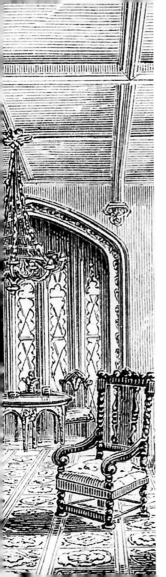

FINISHING TOUCHES

One of the most striking features of the mid-1800s was the wide availability of whole categories of luxuries and furnishings that had been accessible only to the wealthy. What the rich had always been able to procure from individual craftsmen, virtually anyone could now acquire in machine-made versions. New inventions and discoveries, and the rapid refinement of old ones, made popular taste in interior decoration as inconstant as a summer breeze.

Downing's idea of a modern Gothic parlor showed a beamed ceiling, a Gothic-arch mirror, and a Tudor-arch opening for a diamond-paned bay window. The furniture mixes Gothic and Elizabethan influences.

Even people who did not live in Gothic Revival houses were likely to own a piece or two of furniture in the style. Chairs and beds particularly presented irresistible opportunities for tall, arched backs and headboards. Ornate hall chairs, intended for only brief, ceremonial encounters with the human anatomy, were a favorite way to introduce Gothic principles into the tasteful home.

Mahogany, rosewood, and walnut, often used as veneers, were impressive wood finishes. Less expensive woods could be painted or grained to disguise the variations. Otherwise plain wardrobes and other large cabinets took nicely to shallow Gothic-arch panels on their doors. Cast iron was frequently used for chairs and beds, especially in children's and servants' rooms, because it was easy to clean, nearly indestructible, and well suited to the sinuous foliate or arched designs beloved by Gothic Revivalists.

Small home organs and pianos and their accompanying music stands seemed to cry out for an application of pointed arches. Whatnots, or étagères, in Gothic designs were essential to display collections of small, eccentric objects.

John Jelliff of Newark, New Jersey, made this rosewood side chair (above) about 1855. As Pugin illustrated (opposite), carved chair backs in wood or iron often imitated full Gothic gables or the intricate tracery of rose windows.

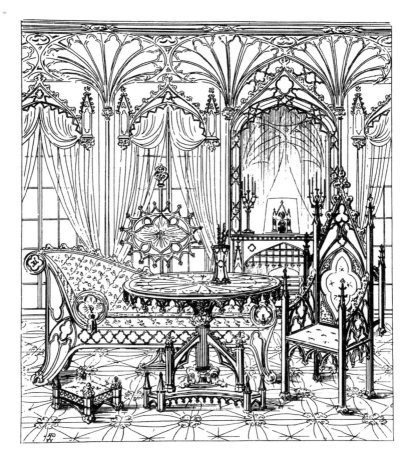

FABRICS AND CARPETS

True Gothicists decried floral patterns found in "tapestry" carpets and selected unshaded, small geometric motifs, preferably in only two colors—although the Gothic arch sometimes turned up even underfoot. This large-scale architectural pattern is a reproduction of an English carpet designed in 1848.

Fabrics of all types rolled in seemingly endless yardage off the looms of textile mills in the mid-1800s. With aniline dyes capable of producing any color imaginable, an era of unprecedented brilliance in decoration and dress ensued—to the dismay of Gothic arbiters of public taste who advocated subdued colors and flat, abstract, geometrical, or vinelike patterns. Richly colored silks, velvets, damasks, and chintzes were all popular.

Thanks to the increasing use of large power looms, wall-to-wall carpeting became the floor covering of choice in middle- and upper-class homes. The carpeting, which came in strips, was especially popular in the United States, where floors were most often of soft woods, rather than the handsome hardwoods used in many English houses. Most carpets were of the relatively inexpensive, machine-made, flat-woven, reversible types known as ingrain and Venetian. Those who could afford them bought machine-made or hand-knotted Axminster, Wilton, or Brussels pile carpets or Oriental rugs. In the summer, straw matting often replaced carpeting, while oilcloths and painted floorcloths were used year-round to protect high-traffic areas such as entry halls and kitchens.

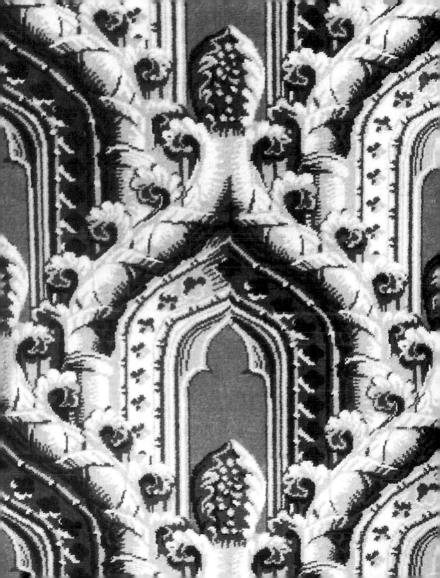

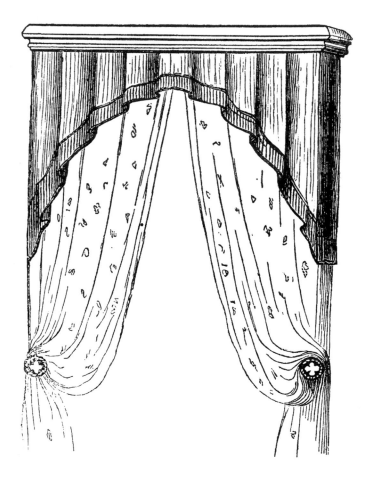

WINDOW COVERINGS

Casement windows with small diamond panes that splashed attractive patterns of dappled light across Gothic Revival interiors generally needed no further treatment. Nor did stained- or painted-glass rose windows.

Windows that were larger and less complete in their own design, however, required some means of ensuring privacy and controlling light. Folding, paneled interior or exterior blinds (shutters) were one way to do so; Venetian blinds were another. Gothicists who yielded to a more decorative impulse might have settled on fabric blinds, printed or handpainted with naturalistic landscapes or castle scenes. Other common window treatments included light curtains of muslin, which shut out bugs, heat, and excessive light, combined with worsted or silk overcurtains and shaped, fabric-covered lambrequins or fringed fabric valances that concealed the curtain rods.

Gothic Revival examples emphasized simplicity in draping and were usually pulled back easily on plain brass rings. Although the valances and lambrequins gave a lavish effect, few housekeepers used much more fabric than was needed to cover the window when the curtains were pulled across it.

In *The Architecture of Country Houses* (1850), Andrew Jackson Downing sketched this window treatment. With its simulated arch in the valance, it was properly Gothic. The curtains were tacked back with decorative pins when not in use.

Cornice: Decorative panel, pole, or painted surface at the top of the window

Valance: Fabric hung below the cornice and over the curtains

Lambrequin: Valance with either a straight or a sculpted edge

Curtains: Fabric panels covering the window

Gothic arches made an appearance even on the cast base of this Argand-burner mantel lamp (ca. 1835–40) with cut-glass shades.

We are violently enamored of gas and of glass. The former is totally inadmissible within doors. Its harsh and unsteady light offends. …The huge and unmeaning chandeliers… which dangle in our most fashionable drawing rooms, may be the quintessence of all that is false in taste or preposterous in folly.
—Edgar Allan Poe,
Philosophy of Furniture,
1840

Edgar Allan Poe complained of the sickly pallor cast by gaslight, and many belles of the era found it necessary to rely heavily on their rouge pots to fend off the unattractive effects of its unrelenting glare. Still, coal-gas wall jets and brackets cast in Gothic shapes, elaborate gaseliers suspended from ceiling medallions, and gas table lamps seemed literally to turn night into day in the eyes of people accustomed to the pale, flickering light of candles and oil lamps.

Astral (starlike), solar (sunlike), and sinumbra (shadowless) oil lamps were improved versions of the Argand oil lamps that had come into use late in the eighteenth century. All relied on high-quality, relatively smokeless oil contained in a ring-shaped tube reservoir within a glass globe. The new lamps, true to their names, promised to produce light as bright and unshadowed as that cast by the sun or the stars, in contrast to dim, inconstant, and inconvenient candles.

In 1859 a safer, cleaner, and more economical fluid began to shed needed light inside: kerosene, billed then as an "absolutely inexhaustible" resource. Hanging, wall, and stationary fixtures were easily and widely converted to use this magic fuel.

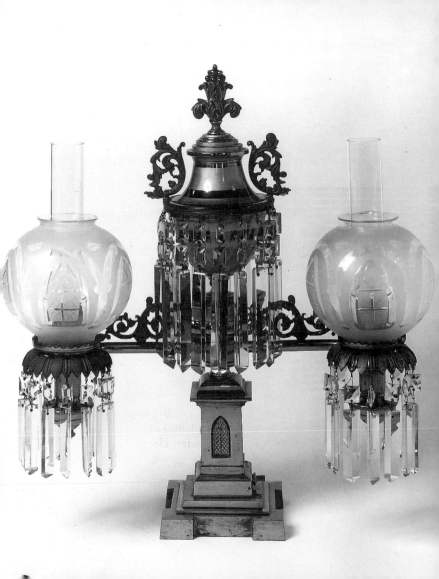

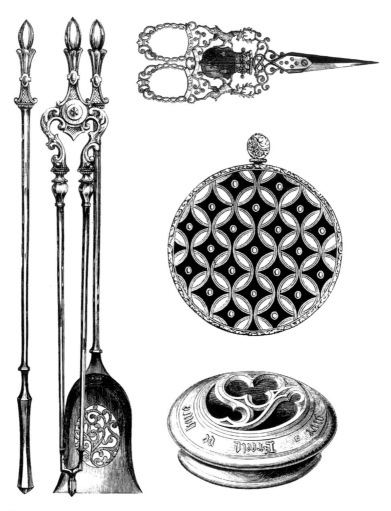

FINISHING TOUCHES

DECORATIVE OBJECTS

Among the awesome products of the industrial revolution was a middle-class society awash in billions of objects. Dresden and Meissen figurines, Staffordshire cottages, portfolios of prints set out on easels in the parlor, and groups of plaster statuettes arrayed on table tops—small, curious objects of every description demanded to be displayed and admired.

By 1860 virtually every household object was, if not decorative, at least decorated. Among the simpler forms of popular decoration was a line of Gothic arches, pressed into objects ranging from cast-iron coal grates to cast-glass pickle bottles, vases, and celery dishes. To compound the accumulative process, the women of the Gothic Revival era busied themselves with quasi-useful decorative handwork—needle cases; pen wipers; doilies; cushions; comb holders of cloth, straw, and cardboard; rustic picture frames fashioned from twigs; and hooked and shirred rugs made from fabric scraps sewn into imaginative scenic patterns.

The movement to return to medieval church ritual also prompted an interest in the highly decorative objects associated with them, such as *prie-dieux* (kneeling benches).

Fireplace tools, scissors, watches, and alms basins were among the myriad household, personal, and church objects displayed at the Great (Crystal Palace) Exhibition of 1851 in London to illustrate the best work of manufacturers around the world.

Machine-made Goods for Gothic Households

Silverplated flatware and candlesticks

China vases, figurines, and cottages

Pressed glassware

Pianos

Mantel clocks

Cast-iron parlor stoves

Inkstands

Epergnes

IN STYLE

A rural cottage for every family was a cherished goal of nineteenth-century social reformers, but commercial and public buildings dominated the Gothic Revival era. As railroad travelers sped about the countryside, hotels found a ready clientele. Meanwhile, the demand grew for modern structures of a size previously unknown: massive factories, warehouses, offices, universities, stores, post offices, prisons, bridges, and, of course, railroad stations.

No structure better illustrates the marriage of Gothic influences and advanced technology of the nineteenth century than the Brooklyn Bridge (1883, John A. Roebling), which still inspires awe a century later.

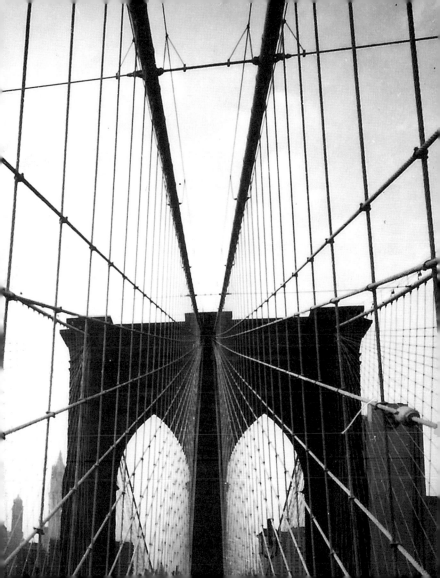

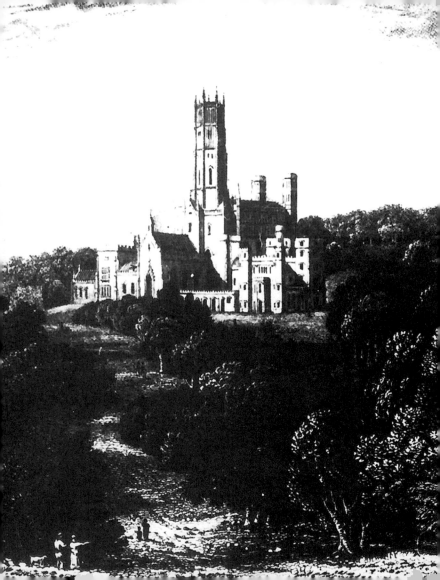

Two design streams met in the Gothic Revival concept of home. One was the large, formal castle, represented at first by such fantasy structures as Walpole's Strawberry Hill and Scott's Abbottsford. These and simpler American designs—Benjamin H. Latrobe's Sedgeley (1799) and Dorsey's Gothic Mansion (ca. 1810) in Philadelphia—often applied Gothic detail to traditional forms.

As the style matured, paralleling Gothic Revival churches, a more comprehensive view evolved. Lyndhurst (1842, 1865), built high on the banks of the Hudson River, epitomizes the American castle. Irregular in shape, with high, gray ashlar walls, proud battlements, and soaring pinnacles, it is among the grandest of many picturesque mansions built in this hauntingly beautiful area.

Gothic castles were scattered throughout the American East and Midwest, but they always looked more natural in England. There large new country estates by John Nash, Sir Charles Barry, Sir George Gilbert Scott, and other Gothic Revivalists sat easily among genuine medieval castles. Although there were some less pretentious Gothic houses, such as church parsonages, England's cottages ornés were often more rustic than Gothic in feeling.

What absurdities, what anomalies, what utter contradictions do not the builders of modern castles perpetrate! … [The] whole building is an ill-conceived lie!
—A.W.N. Pugin, *The True Principles,* 1841

Historian Kenneth Clark called Fonthill Abbey (opposite) "the most exciting building of its time"—the first of the Gothic Revival creations meant to inspire awe or terror. Home to Gothic writer William Beckford, the 1796 English castle's tower collapsed in 1825. America's first Gothic villa was Glen Ellen (1832, Town and Davis) Towson, Maryland.

GOTHIC COTTAGES

The temples and cathedrals are the orations and epic poems, the dwelling-houses the familiar epistles or conversations of the particular styles.
—Andrew Jackson Downing, *Cottage Residences,* 1842

The 1873 edition of Downing's *Cottage Residences* presented this idyllic cottage "suitable for a Gate Lodge...or for a small Family." For pleasing effect, Downing suggested vines and creepers to render exterior portions of the house "rich with blossoms, verdure and fragrance, perfect wonders of natural beauty."

In the United States the small Gothic cottage best characterized Gothic Revival residences. Ironically, it was A. J. Davis, architect of the New York castle Lyndhurst, who supplied the designs for many of these little Gothic homes. Andrew Jackson Downing, in his inexpensive and vastly influential books illustrated with Davis's designs for both Gothic and Italianate cottages, effectively promoted not just a mode of building but the physical and moral benefits of a simple rural life as well.

The so-called Downingesque cottage, in which such a life was meant to be lived, was marked by a steeply pitched roof, often with a center front gable, ornamental wooden bargeboards in Gothic motifs, pinnacles, pendants, and, inevitably, the pointed arch that became the common denominator of the style. Porches on Gothic cottages were not mere entrances but gathering places for families and guests, often entirely covering one or more sides of the house. Although popular books such as Calvert Vaux's *Villas and Cottages* (1857) and Gervase Wheeler's *Rural Homes* (1851) were directed to rural and suburban building, the appeal of Gothic ornament extended even to the city, where it was sometimes applied to rowhouses.

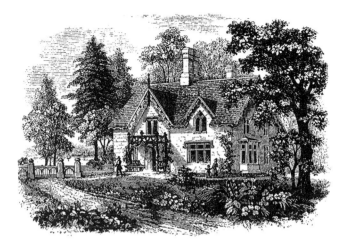

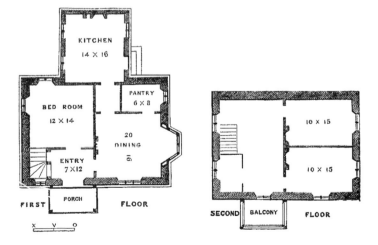

KITCHEN
14 × 16

BED ROOM
12 × 14

PANTRY
6 × 8

ENTRY
7 × 12

20
DINING
16

FIRST PORCH FLOOR

x v o

10 × 15

10 × 15

SECOND BALCONY FLOOR

What could be further removed from Pugin's principles of church architecture than Gothic elevator doors in a late Gothic Revival skyscraper? Nonetheless, New York's Woolworth Building (1913, Cass Gilbert) was once known as the Cathedral of Commerce.

Commercial Cathedrals

Oriel Chambers (1865, Peter Ellis), Liverpool
Wool Exchange (1867, Lockwood and Mawson), Bradford, England
Brown and Company (1875, J. Morgan Slade)
St. Pancras Station and Hotel (1874, Sir George Gilbert Scott), London
Chicago Tribune Building (1925, Howells and Hood), Chicago

As the industrial age wore on, new building types emerged to house commerce and industry. Large stores and commercial buildings five or more stories high lined city streets and created urban centers of business. At the beginning of the nineteenth century financial offices such as the Bank of Philadelphia (1808, Benjamin H. Latrobe) were discreetly decorated in the Gothic manner. Later such buildings were occasionally designed in full Gothic Revival style. Horace Jayne's eight-story stone skyscraper (1850, William Johnston and Thomas U. Walter) was a Philadelphia monument to an empire erected on patent medicines.

Stylish stone facades concealed brick walls and interiors supported by iron columns and sometimes iron beams. Newly affluent middle-class shoppers browsed through stores with first-floor facades of glass and cast-iron and elaborate Gothic interior details.

Hotels, a world apart from the rough-and-ready inns of the eighteenth century, served rail travelers and business interests as well as vacationers. Large, steam-powered factories at the edges of urban cores and along waterfronts spewed out their goods, making former luxuries widely available.

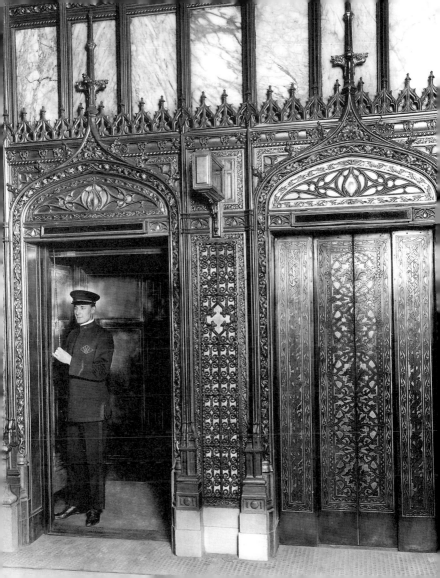

CHURCHES

A.W.N. Pugin gave voice to the Gothic Revival era's yearnings for "moral" designs.

Perhaps the best-known Gothic Revival church in the United States is St. Patrick's Cathedral (1879, James Renwick) in New York.

A pointed church is the masterpiece of masonry.
—A.W.N. Pugin, *The True Principles,* 1841

The heart of the Gothic Revival lay in the thousands of churches that were built after publication of A.W.N. Pugin's *The True Principles of Pointed or Christian Architecture* (1841). The English church made creative use of Gothic designs, notably in the urban form exemplified by All Saints, Margaret Street (1859, William Butterfield), London. The period also ushered in the church restoration movement, led by Sir George Gilbert Scott in England and Eugène Viollet-le-Duc in France.

The United States, of course, had no medieval churches to restore or copy, although Gothic ornament was not uncommon. In the late 1830s architects John Notman and Richard Upjohn were inspired to move beyond mere decoraton to recreate the picturesque form of the rural English parish church. Notman's and Upjohn's churches—among them St. Mark's (1852) in Philadelphia and Trinity (1846) in New York City—were so popular that by the 1850s they were widely imitated. In rural areas churches were often in Carpenter Gothic, with vertical board-and-batten siding and simplified designs. Urban edifices rivaled the cathedrals of Europe, giving Gothic a steady place in churches well into the twentieth century.

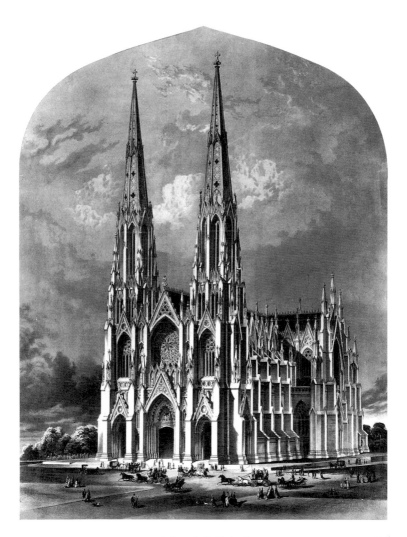

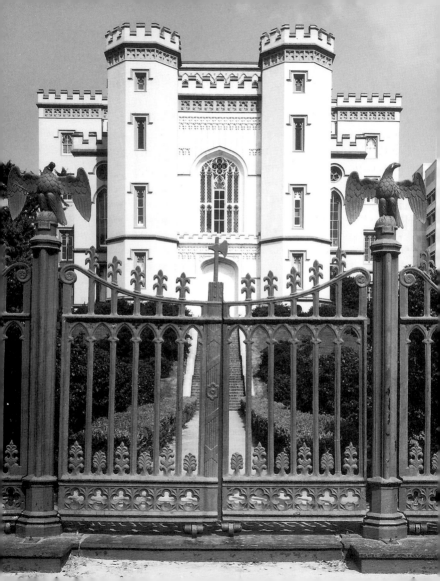

In England Gothic public buildings extended the idea of the castle as a public edifice—the Tower of London, for instance—and reflected the general conviction that Gothic architecture represented a national style. The rebuilding of the fire-ruined Houses of Parliament by 1870 spurred intense interest in the Gothic Revival, and it was subsequently used for the most important new public buildings, including G. E. Street's Royal Courts of Justice (1882). In England and on the continent, however, the nineteenth century was principally a period of restoration and rebuilding of existing medieval relics.

America preferred the Greek and Classical Revival styles, but the citizens of a rapidly growing new nation—as the United States then was—took no little pride in architectural diversity. Many a Gothic Revival courthouse, city hall, and statehouse thus adorned towns across the country. Notable were the Old Louisiana State Capitol (1849, James Dakin) and the Richmond City Hall (1894, Elijah E. Meyers), an impressive Victorian Gothic edifice. Ottawa's Canadian Dominion Parliament Buildings (1867, Thomas Fuller), however, became the most significant group of Gothic public buildings in North America.

Sir Walter Scott is probably responsible for the [Louisiana] Capitol building, for it is not conceivable that this little sham castle would have been built if he had not run the people mad, a couple of generations ago, with his Medieval romances. The South has not yet recovered from the debilitating effects of his books.
—Mark Twain, *Life on the Mississippi,* 1883

At the castellated Old Louisiana State Capitol in Baton Rouge, even the eagles atop the gateposts on the cast-iron fence look Gothic.

The exterior of a prison should . . . be formed in the heavy and sombre style, which most forcibly impresses the spectator with gloom and terror.
—*Encyclopedia Londinensis*, 1826

Faced with intolerable prison conditions in which crowding and lack of sanitation made survival of the prisoner questionable at best, an early nineteenth-century reform movement led to the concept of the humane penitentiary. Here, in individual cells, prisoners would have the opportunity to reflect on and repent of their errors.

In the new penal system, fresh air and sanitation were as important as the efficient containment of prisoners, but the need to surround them with unscalable walls gave rise to a dark and ponderous architecture indeed. It was a program for which the more melancholy Gothic castle forms seemed a

natural and creative expression. The work of John Haviland and pioneer prisons such as his Eastern State Penitentiary (1836) in Philadelphia created great interest in Europe in the new American scheme.

Closely related to prisons in this line of reformist thinking were insane asylums, which were recognized as scandalously inhumane in their treatment of inmates. Large numbers of mental hospitals thus were built in the United States for the incarceration—and, it was hoped, the cure—of the mentally troubled. St. Elizabeth's Hospital (1852, Thomas U. Walter) in Washington, D.C., is one such institution constructed in the proper Gothic style.

Philadelphia's Eastern State Penitentiary was a model of humane treatment, but its fortress-like appearance defined prisons for many years.

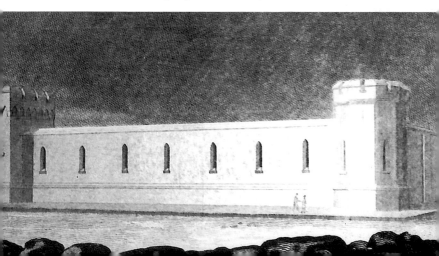

Education in the Gothic era was beginning to be viewed not merely as an exclusive privilege of wealthy males, but as something society required of the middle and working classes as well—sometimes even of women. The lines of the Gothic Revival style—from the castle or the cathedral—seemed perfect for academic buildings: sober, uplifting, and strongly imbued with overtones of morality and earnest aspiration.

Among the most representative developments of the period in the United States was the rise of the military school. Institutions such as the Virginia Mili-

Towers and pinnacles pointing heavenward, the Yale College Library (1842, Henry Austin) in New Haven, Connecticut, was nearly churchlike in reverence—for learning. The design recalls, in miniature, King's College Chapel at Cambridge, England.

tary Institute (1848–61) in Lexington, Virginia, and the U.S. Military Academy (1903–14) at West Point, New York, owe much of their aura to castellated buildings in the Gothic mode.

Prominent among the many architects who contributed to the blossoming of collegiate Gothic designs in the early twentieth century were Ralph Adams Cram (Princeton University Graduate College, 1911–29); James Gamble Rogers (Harkness Memorial Tower, Yale, 1917); and Henry Ives Cobb (plan and Gothic buildings, University of Chicago, 1891–1900).

Collegiate Gothic

Farnam Hall, Yale University (1869, Russell Sturgis)

Trinity College master plan (1881, William Burges)

Bryn Mawr (1890s, Addison Hutton; Cope and Stewardson)

University of Pittsburgh (1925, Charles Z. Klauder)

Duke University (1930s, Horace Trumbauer)

Intended to be inspiring rather than gloomy, cemeteries such as Mount Auburn were often embellished with graceful gatehouses, chapels, iron fences, and elaborate stone or cast-iron tombs executed in the Gothic mode. Jacob Bigelow's chapel in the pointed style dates from 1845.

At Laurel Hill (pages 86–87) and in other peaceful settings of natural beauty, families quietly took the air while pondering the certainty of death and the proper conduct of their lives.

Perhaps no aspect of the Gothic Revival period stirred more romantic, gently melancholic, and other-worldly emotions than the large, picturesque cemetery. Laid out on hilly, evocative sites, cemeteries became destinations for contemplative Sabbath outings and thus forerunners of urban public parks.

The great American cemeteries included the first "rural" cemetery, Mount Auburn (1831) in Cambridge, Massachusetts; Laurel Hill (1839) in Philadelphia; Greenwood (1840) in Brooklyn, New York; and Hollywood (1860) in Richmond. Some were designed by prominent architects, such as John Notman (Laurel Hill and Hollywood). Even small, remote towns built modest versions. Parisians visited the picturesque Père la Chaise cemetery on their Sundays in the park.

Less melancholy but no less picturesque were the pleasure parks of the era. Curving walks and driveways wound through small forests, around lakes, along waterways, and across ornate iron bridges, providing relief and recreation for the city dweller—from the Bois de Boulogne in Paris and the Prater in Vienna to New York's Central Park (1876) and Fairmount Park (1868) in Philadelphia, the largest urban park in the world.

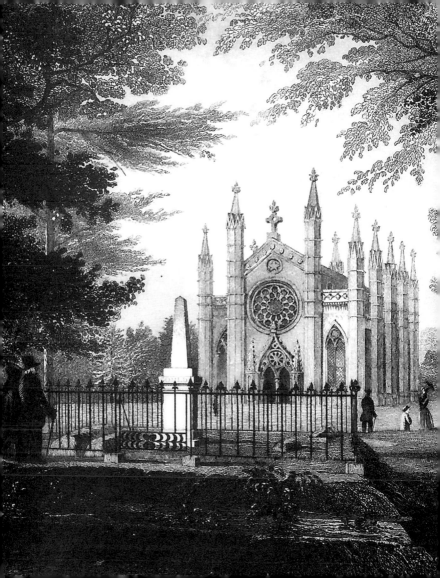

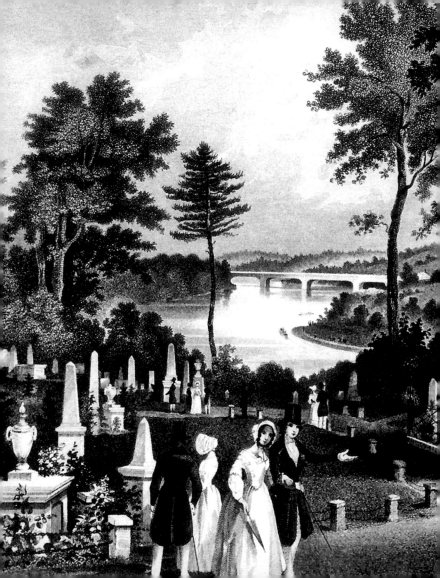

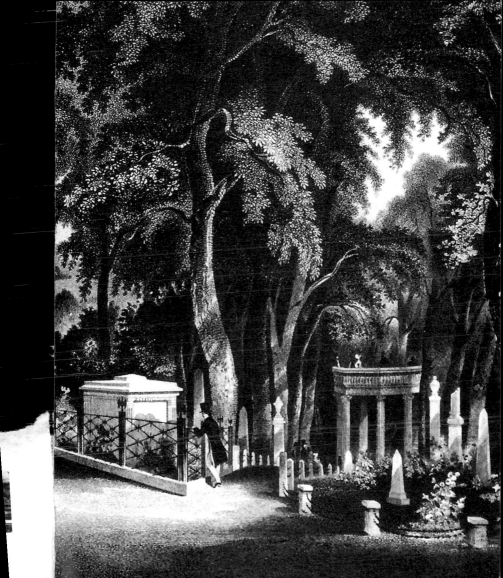

From traveling shows and circuses to operas and oratorios, the Gothic Revival era offered a kaleidoscope of entertainment activities. Museums brought scientific curiosities and fine art to many, often in impressive Gothic structures, such as the old Boston Museum of Fine Arts (1878, John Sturgis) and Frank Furness's Pennsylvania Academy of the Fine Arts (1876), a Venetian Gothic confection. At Brighton,

The Cincinnati Music Hall (1879, Samuel Hannaford) was an elaborate High Victorian Gothic example of the opera house. Every small town coveted its own little version of such a structure.

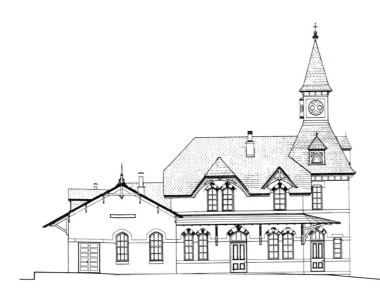

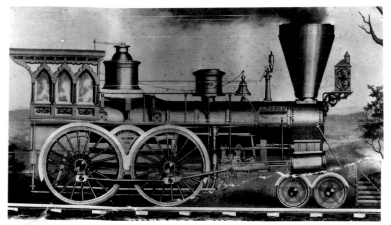

IN STYLE

Bath, Baden-Baden, Saratoga Springs, and other spas, visitors arrived to "take the waters" for health or pleasure. Seashore resorts such as Cape May and Atlantic City, New Jersey, blossomed with the railroads, and religious camp meetings sought moral uplift at sites like Oak Bluffs on Martha's Vineyard, Massachusetts. At more worldly venues— Saratoga Springs, New York, for example— public horse racing came into vogue.

The Crystal Palace

Date: 1851

Designer: Joseph Paxton

Event: Great Exhibition

Place: Hyde Park, London

Size: 770,000 square feet

Materials: Prefabricated iron frame covered with glass panels

Burned: 1936

One nineteenth-century traveler, an eccentric New Jersey bishop, actually had himself packed up and hauled by freight car. His trip may have been about as comfortable as most. Moving at speeds that dazzled and often terrified observers—more than forty miles per hour at top speed!—trains seduced the Gothic imagination with their clatter and haste. Yet early rail travel was dirty, tedious, uncomfortable, and on occasion dangerous. Motion sickness from the incessant swaying and vibration assailed passengers even in first-class cars, the best of which were dark, airless, unheated, and overcrowded.

An attractive travel alternative was the steamboat, introduced in 1809 by Robert Fulton, and the paddlewheel, which was in wide intercity use on major rivers by the 1850s. Even ship travel presented problems and dangers, however. Andrew Jackson Downing perished after an 1852 explosion.

The rapid growth of railways spawned two major new building types: the railroad passenger station and the iron and glass train shed, both common by the 1850s. Despite the belief that Gothic design could be used for any structure, that theory was rarely put to the test in these innovative building types.

Going by railroad I do not consider as traveling at all; it is merely being "sent" to a place, and very little different from becoming a parcel.
—John Ruskin, *Modern Painters*, 1843–60

Gothic arches graced both stations and trains alike: a High Victorian Gothic addition (1873, Baldwin and Ponnington) to the Point of Rocks Station in Maryland and the 1854 Auburn passenger locomotive.

SOURCES OF INFORMATION

American Institute
of Architects
1735 New York
Avenue, N.W.
Washington, D.C. 20006

American Society
of Landscape Architects
4401 Connecticut
Avenue, N.W.
Washington, D.C. 20008

L'Association des Vieilles
Maisons Françaises
93, rue de l'Université
75005 Paris, France

The Athenaeum
of Philadelphia
219 South Sixth Street
Philadelphia, Pa. 19106

Heritage Canada
Foundation
P.O. Box 1358, Station B
Ottawa, Ontario K1P 5R4,
Canada

Historic American
Buildings Survey and
Historic American
Engineering Record
National Park Service
U.S. Department
of the Interior
P.O. Box 37127
Washington, D.C.
20013-7127

National Register
of Historic Places
National Park Service
U.S. Department
of the Interior
P.O. Box 37127
Washington, D.C.
20013-7127

National Trust for
Historic Preservation
1785 Massachusetts
Avenue, N.W.
Washington, D.C. 20036

National Trust
for Places
of Historic Interest
or Natural Beauty
36 Queen Anne's Gate
London SW1H 9AS,
England

Society of Architectural
Historians
1232 Pine Street
Philadelphia, Pa. 19107

Strong Museum
One Manhattan Square
Rochester, N.Y. 14607

Victorian Society
in America
219 South Sixth Street
Philadelphia, Pa. 19106

Victorian Society
1 Priory Gardens
Bedford Park
London W4 1TT,
England

SITES TO VISIT

*See also places cited
in the text.*

Albert Memorial (1872)
London, England

**Ca 'D' Zan (John
Ringling House) (1926)**
Sarasota, Fla.

**Chicago Water Tower
(1869)**
Chicago, Ill.

**Christ Church Cathedral
('1853)**
Frederickton, N.B.,
Canada

**Connecticut State
Capitol (1880)**
Hartford, Conn.

**Green-Meldrim House
(1856)**
Savannah, Ga.

The Hermitage (1845)
Ho-Ho-Kus, N.J.

**Jefferson Market Library
(1876)**
New York, N.Y.

Kingscote (1841, 1881)
Newport, R.I.

**Moses Fowler House
(1852)**
Lafayette, Ind.

Rijksmuseum (1885)
Amsterdam, The
Netherlands

**Roseland Cottage
(1846)**
Woodstock, Conn.

**St. Denys-de-l'Estre
(1867)**
St. Denis, France

St. Eugène (1855)
Paris, France

**St. Mark's Church (1852,
1902)**
Philadelphia, Pa

**San Francisco Plantation
(pre-1856)**
Reserve, La.

**Sen. Justin Morrill
House (1851)**
Stafford, Vt.

**Sir Walter Scott
Monument (1846)**
Edinburgh, Scotland

**University Museum
(1859)**
Oxford, England

Vallejo House (1852)
Sonoma State Historical
Park, Calif.

Votivkirche (1879)
Vienna, Austria

**Washington National
Cathedral (1990)**
Washington, D.C.

**Wedding Cake House
(1826, 1855)**
Kennebunk, Me.

CREDITS

Endpapers: Ogbourne St. George carpet reproduction, Woodward Grosvenor and J. R. Burrows and Company

Page 1: Stone panel, *Art Foliage* (1873, James K. Colling), Boston
Page 2: Lyndhurst (1842, 1865, A. J. Davis), Tarrytown, N.Y.
Page 5: Rotch House (1846, A. J. Davis), New Bedford, Mass.

Produced by Archetype Press, Inc.
Project Director: Diane Maddex
Art Director: Robert L. Wiser

First edition

Library of Congress Cataloging-in-Publication Data
Massey, James C.
Gothic revival / James Massey and Shirley Maxwell.
 p. cm. — (Stylebooks)
"An Archetype Press book."
ISBN 1-55859-823-5
1. Gothic revival (Art) I. Maxwell, Shirley. II. Title III. Series.
N6465.G68M37 1994
724'.3–dc20 94-18570

RECOMMENDED READING

Brooks, Michael W. *John Ruskin and Victorian Architecture.* New Brunswick, N.J.: Rutgers University Press, 1987.

Clark, Kenneth. *The Gothic Revival.* 1928. Reprint. Harmondsworth: Penguin, 1962.

Eastlake, Charles L. *A History of the Gothic Revival.* London: Longmans, Green, 1872.

Hitchcock, Henry-Russell. *Architecture: Nineteenth and Twentieth Centuries.* 1958. 1963. 2nd ed. Reprint. New York: Viking Penguin, 1977.

Howe, Katherine S., and David B. Warren. *The Gothic Revival Style in America, 1830–1870.* Seattle: University of Washington Press, 1976.

Leighton, Anne. *American Gardens of the Nineteenth Century.* Amherst: University of Massachusetts Press, 1987.

Loth, Calder, and Julius Trousdale Sadler, Jr. *The Only Proper Style.* Boston: New York Graphic Society, 1975.

Maas, John. *The Gingerbread Age.* New York: Rinehart, 1957.

Moss, Roger W., and Gail Caskey Winkler. *Victorian Exterior Decoration.* New York: Holt, 1987.

Peck, Amelia, ed. *Alexander Jackson Davis.* New York: Rizzoli, 1992.

Pierson, William H., Jr. *American Buildings and Their Architects: Technology and the Picturesque.* New York: Doubleday, 1978.

Stanton, Phoebe B. *The Gothic Revival and American Church Architecture.* Baltimore: Johns Hopkins University Press, 1968.

———. *Pugin.* New York: Viking, 1971.

Upjohn, Everard. *Richard Upjohn: Architect and Churchman.* 1939. Reprint. New York: Da Capo, 1968.

Winkler, Gail Caskey, and Roger W. Moss. *Victorian Interior Decoration.* New York: Holt, 1986.